Women of the Grand Theatre

Posters of the Glamourous Women of the Early 20th Century

By, Patrick W. Nee

~Grand Posters of the Past™~

World Great Art™ Publishing

www.WorldGreatArt.com

World Great Art™ Publishing
Published by:
World Great Art Publishing
96 Walter Street/ Suite 200
Boston, MA 02131, USA
Tel: 617-354-7722
www.WorldGreatArt.com

Copyright © 2013 by PWN

World Great Art is a Registered Trademark. "Posters of the Past" is a Trademark of World Great Art Publishing.

All Rights are reserved under International, Pan-American, and Pan-Asian Conventions. No part of this book may be reproduced in any form without the written permission of the publisher and author. Reviewers may quote brief passages in reviews. Disclaimer: No part of this publication may be reproduced or transmitted in any form or by any means, mechanical or electronic, including photocopying or recording, or by any information storage and retrieval system, or transmitted by email without written permission from the publisher. All rights vigorously enforced. All artwork is copyrighted by World Great Art Publishing.

For ordering posters of prints, contact manager@worldgreatart.com

World Great Art™ Publishing

www.WorldGreatArt.com

CHAS. H. YALE'S EVERLASTING

DEVIL'S AUCTION

20TH EDITION AND BEST EVER

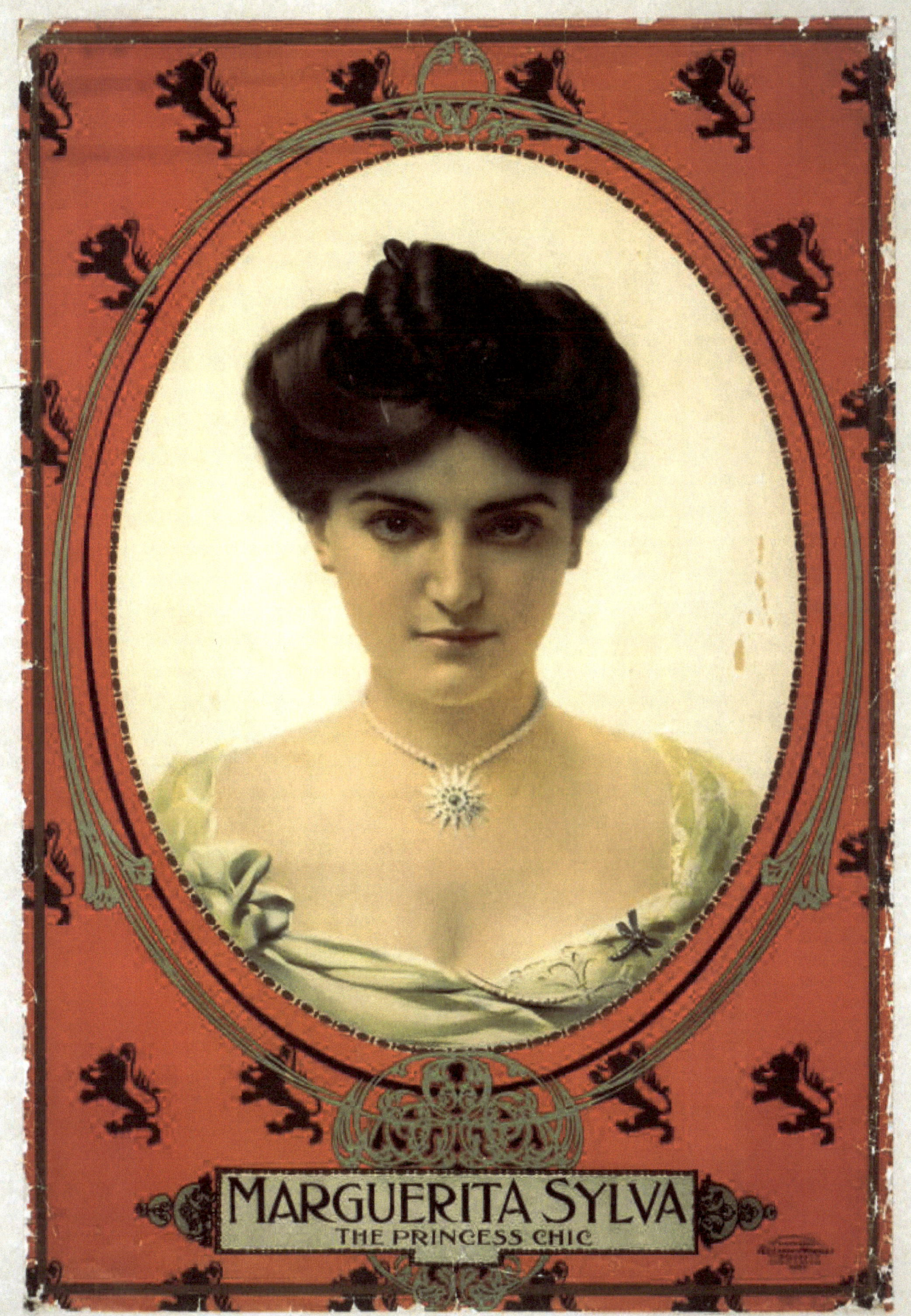

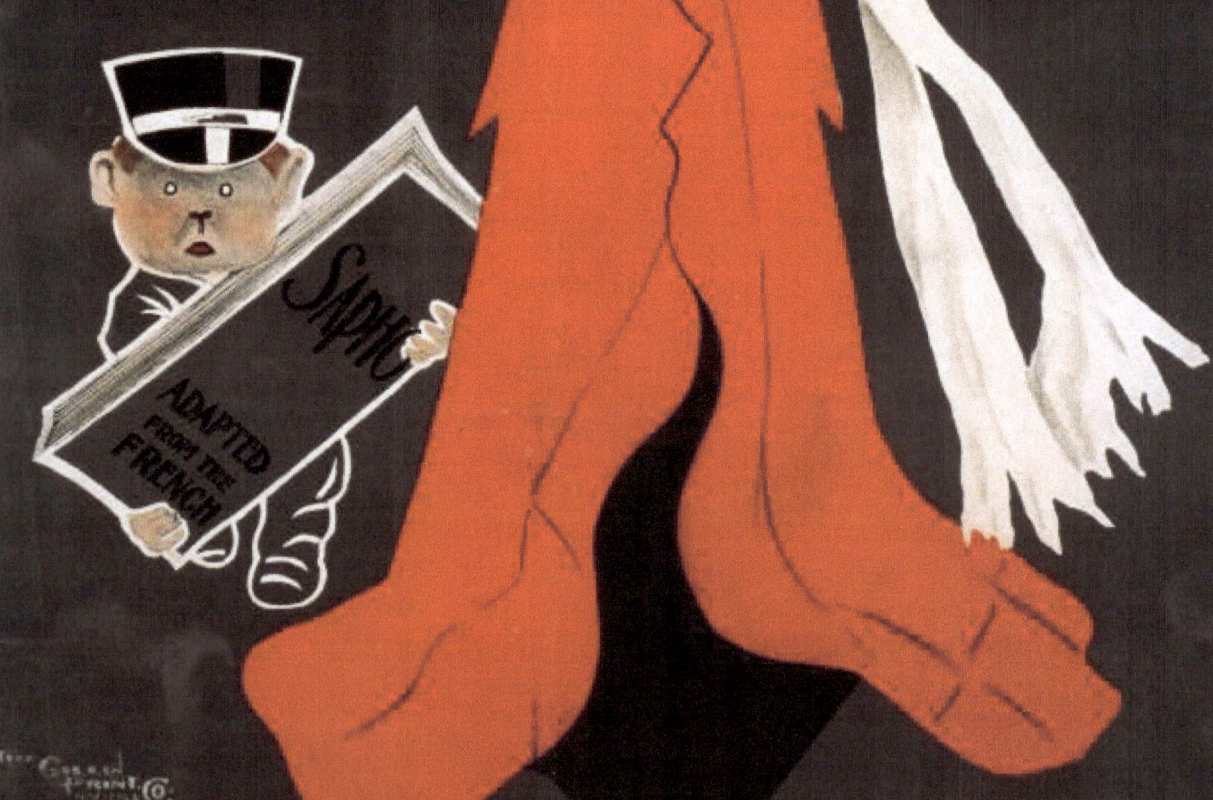

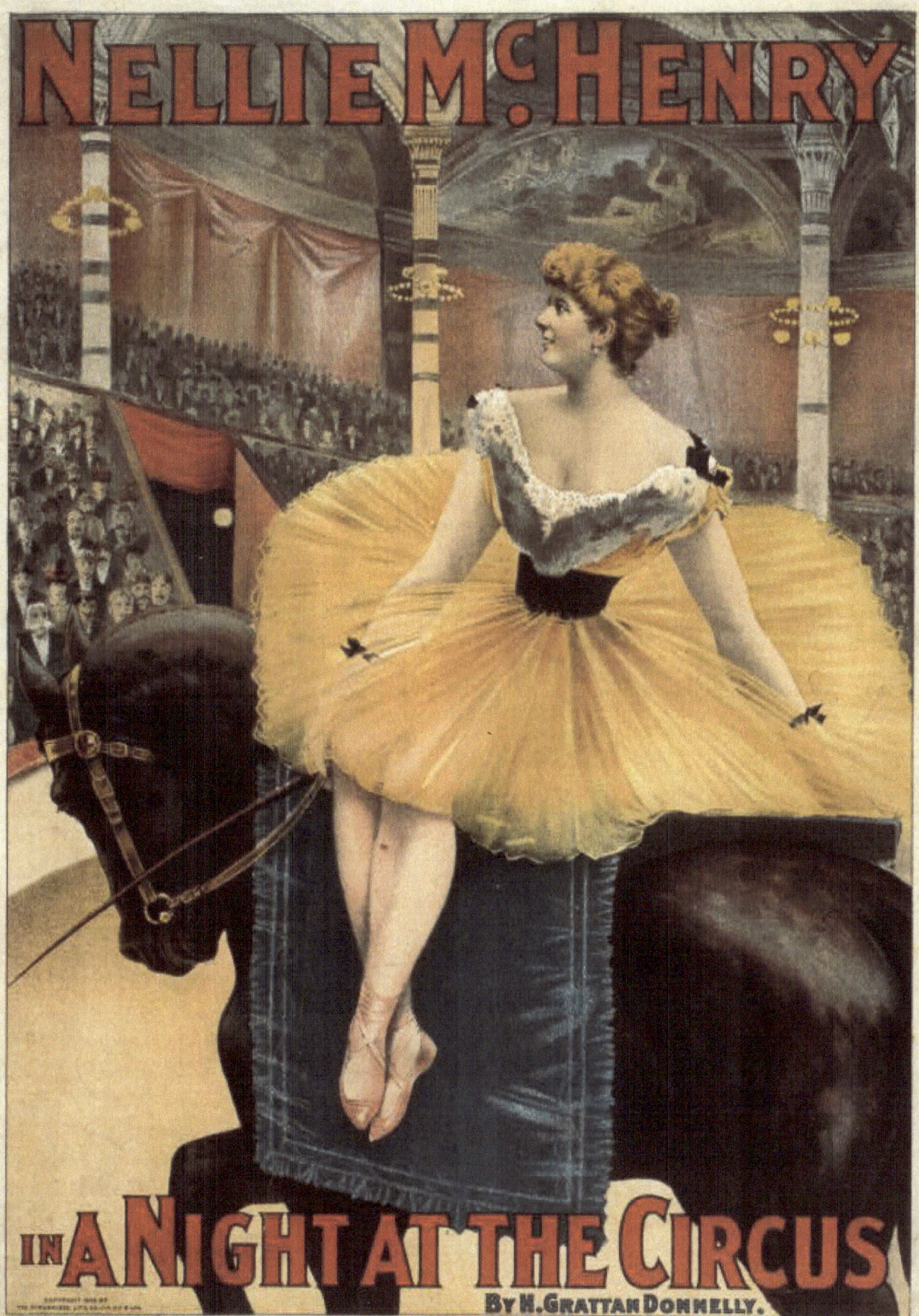

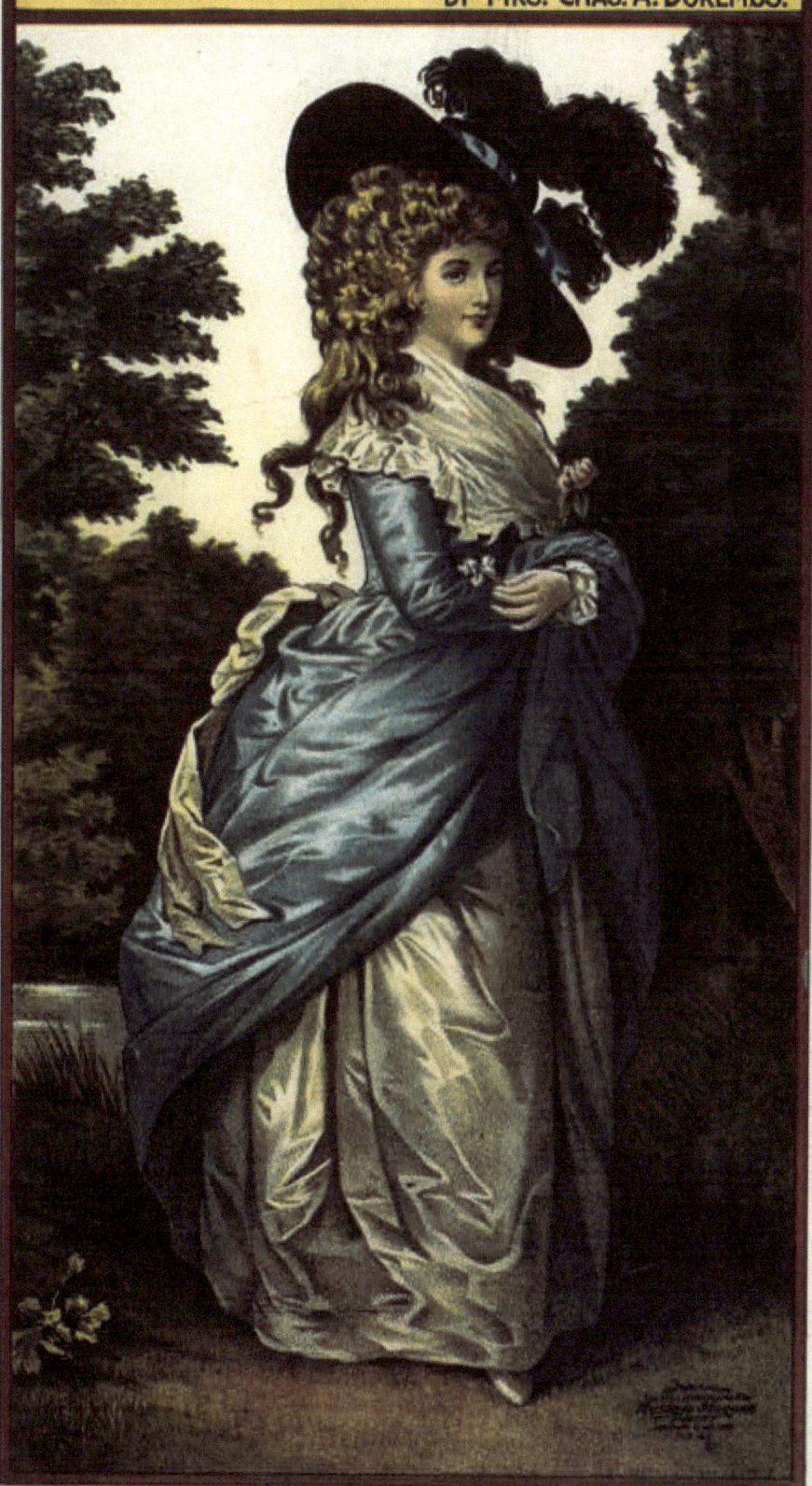

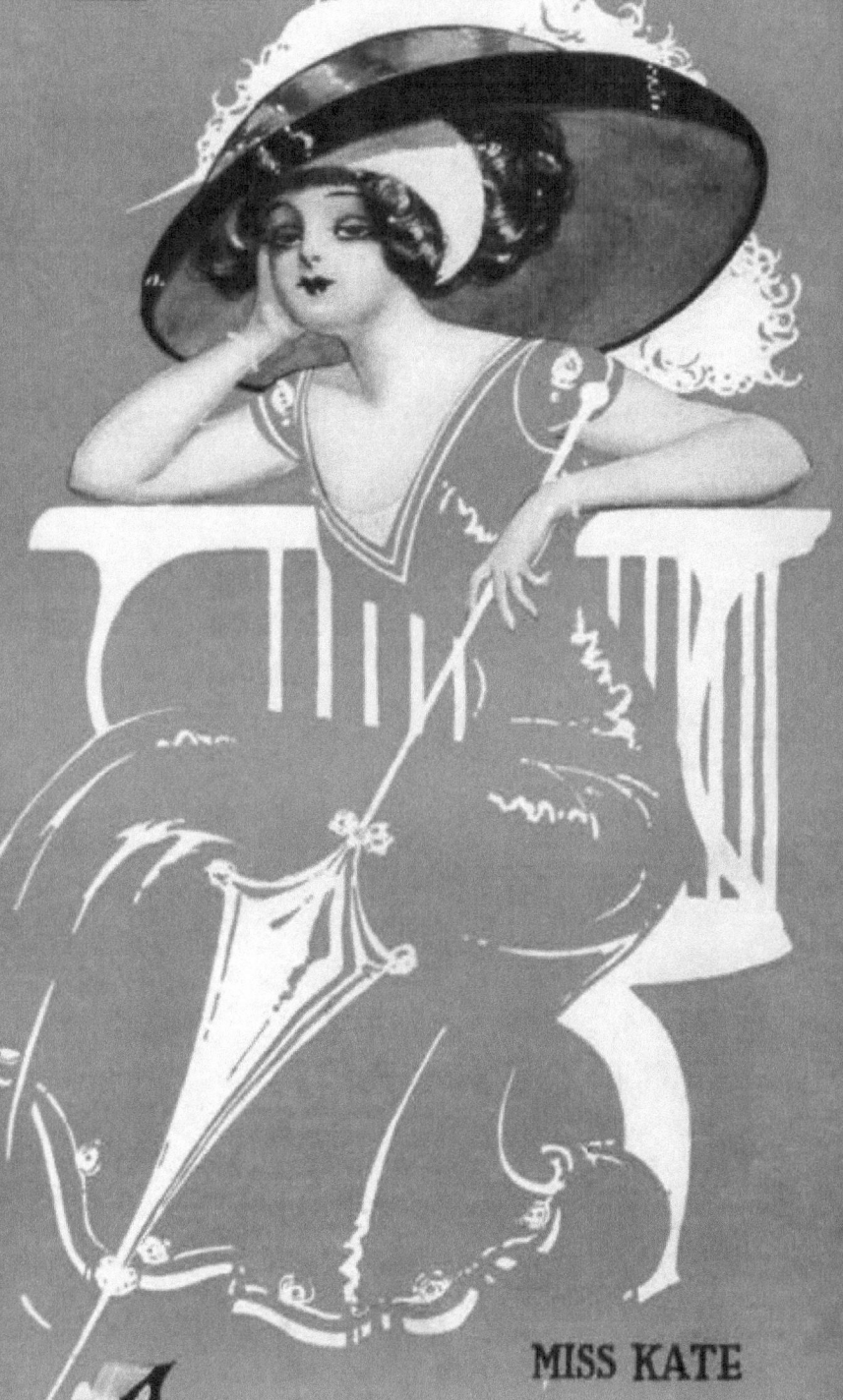

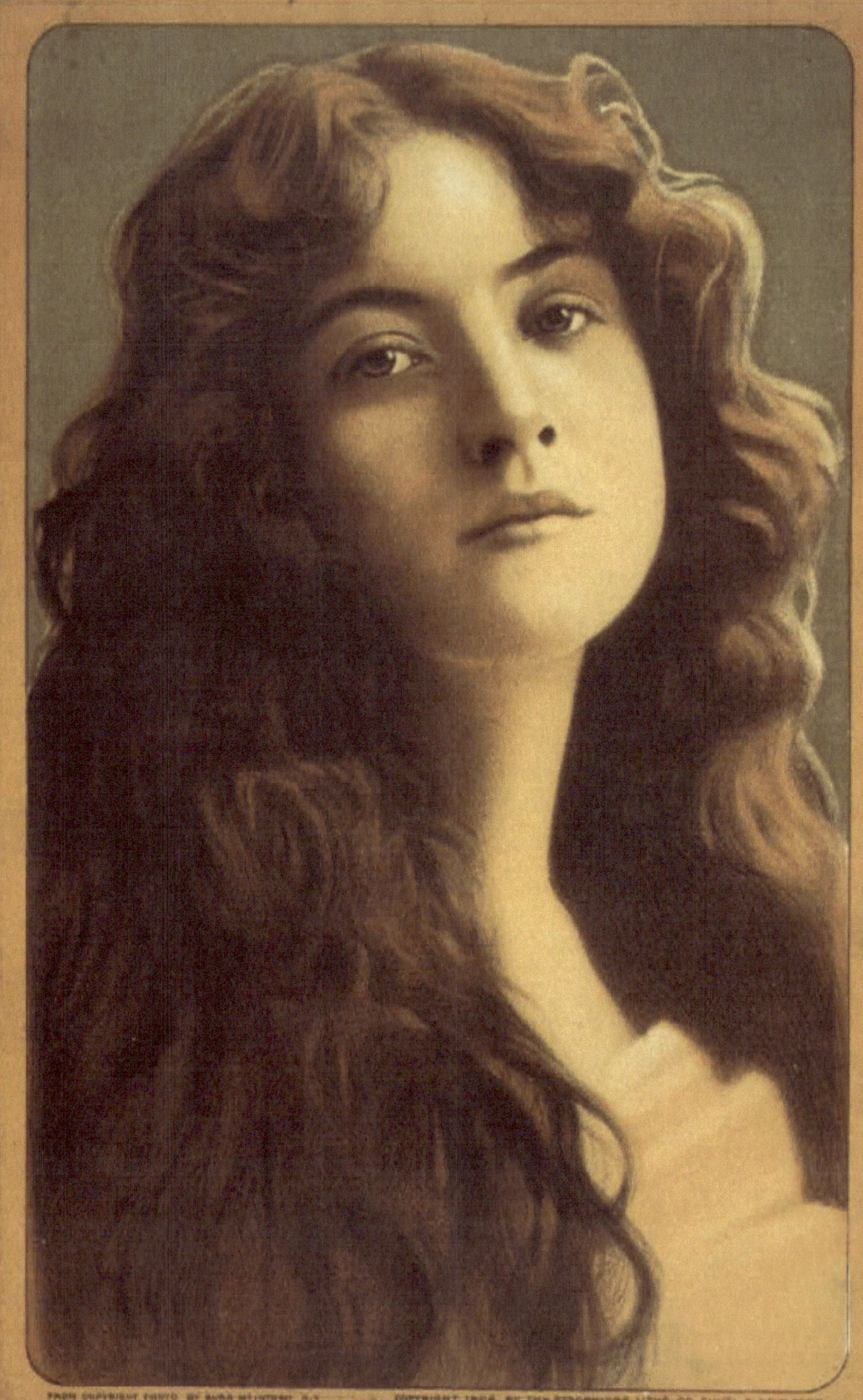

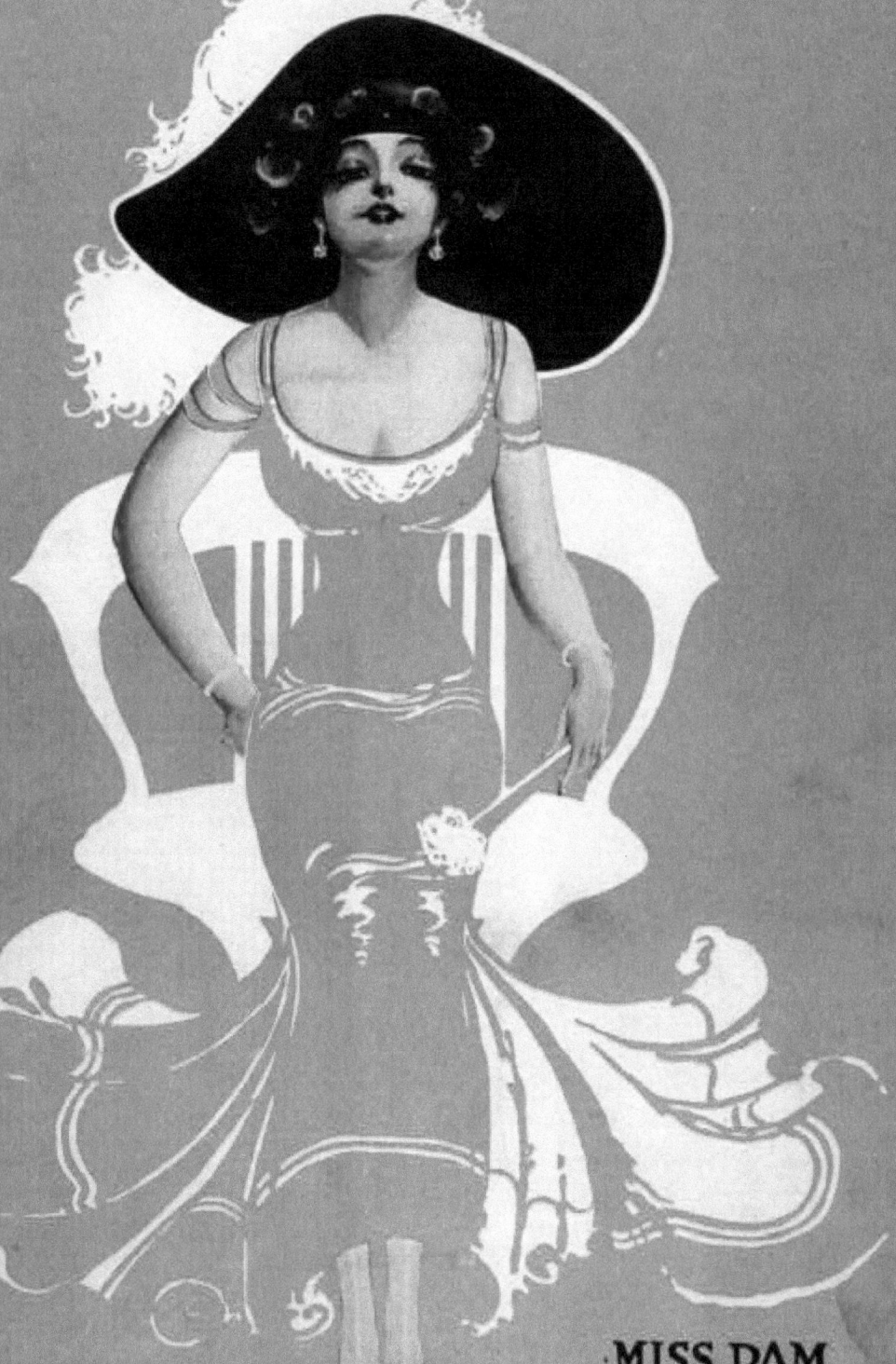

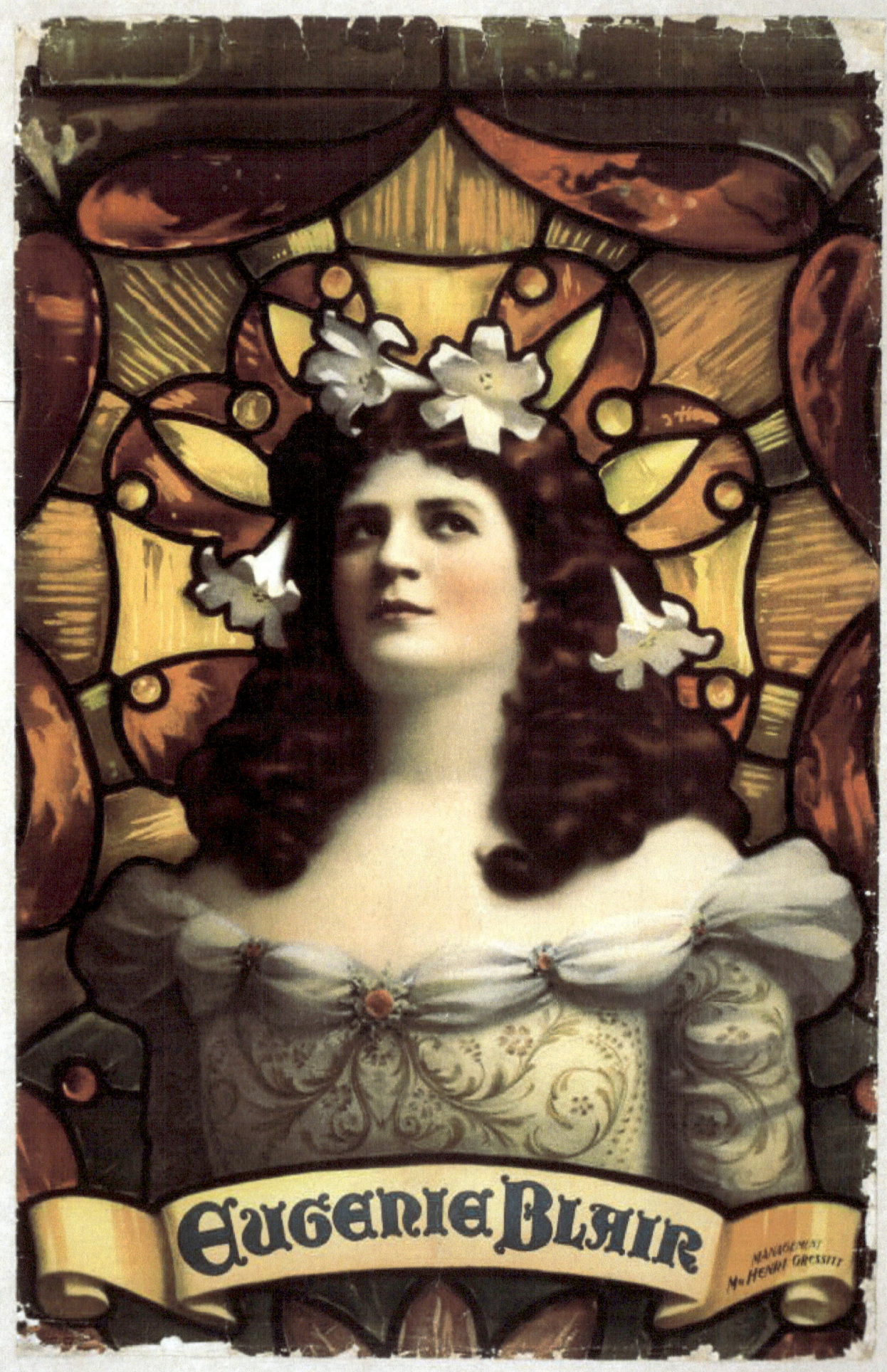

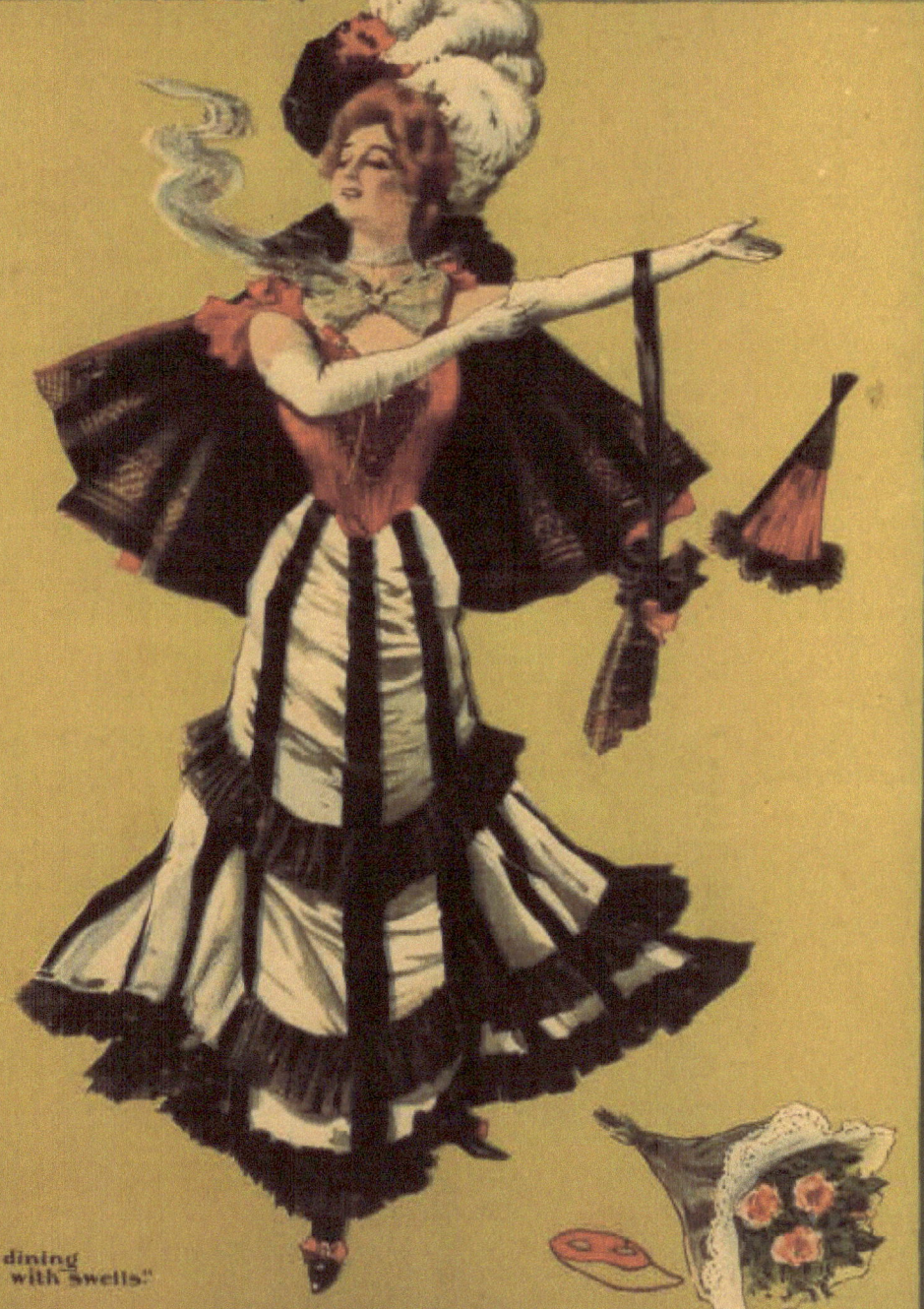

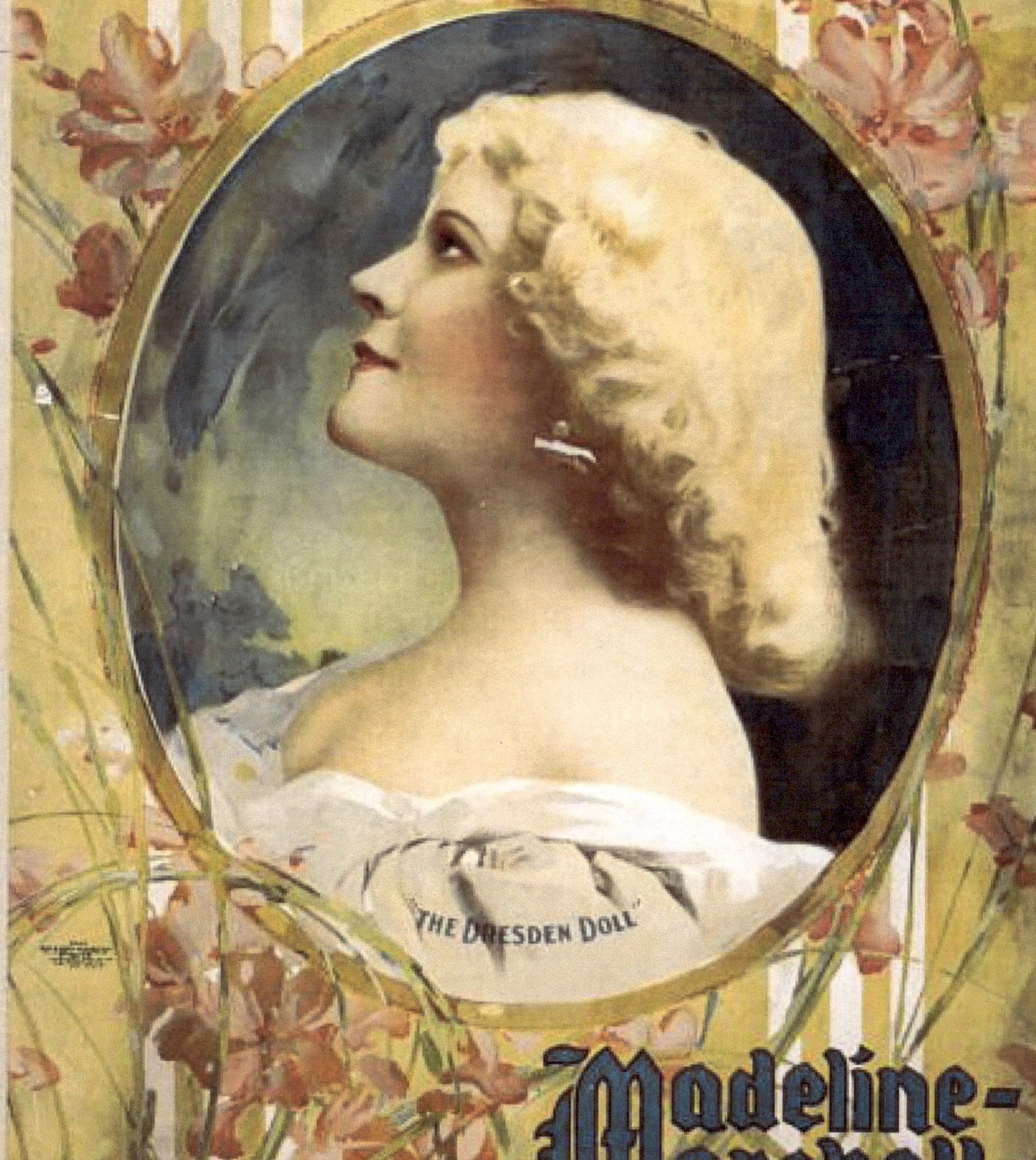

FERRIS' COMEDIANS

EMILY BATLO

Pre-eminent! Progressive!! Popular!!!

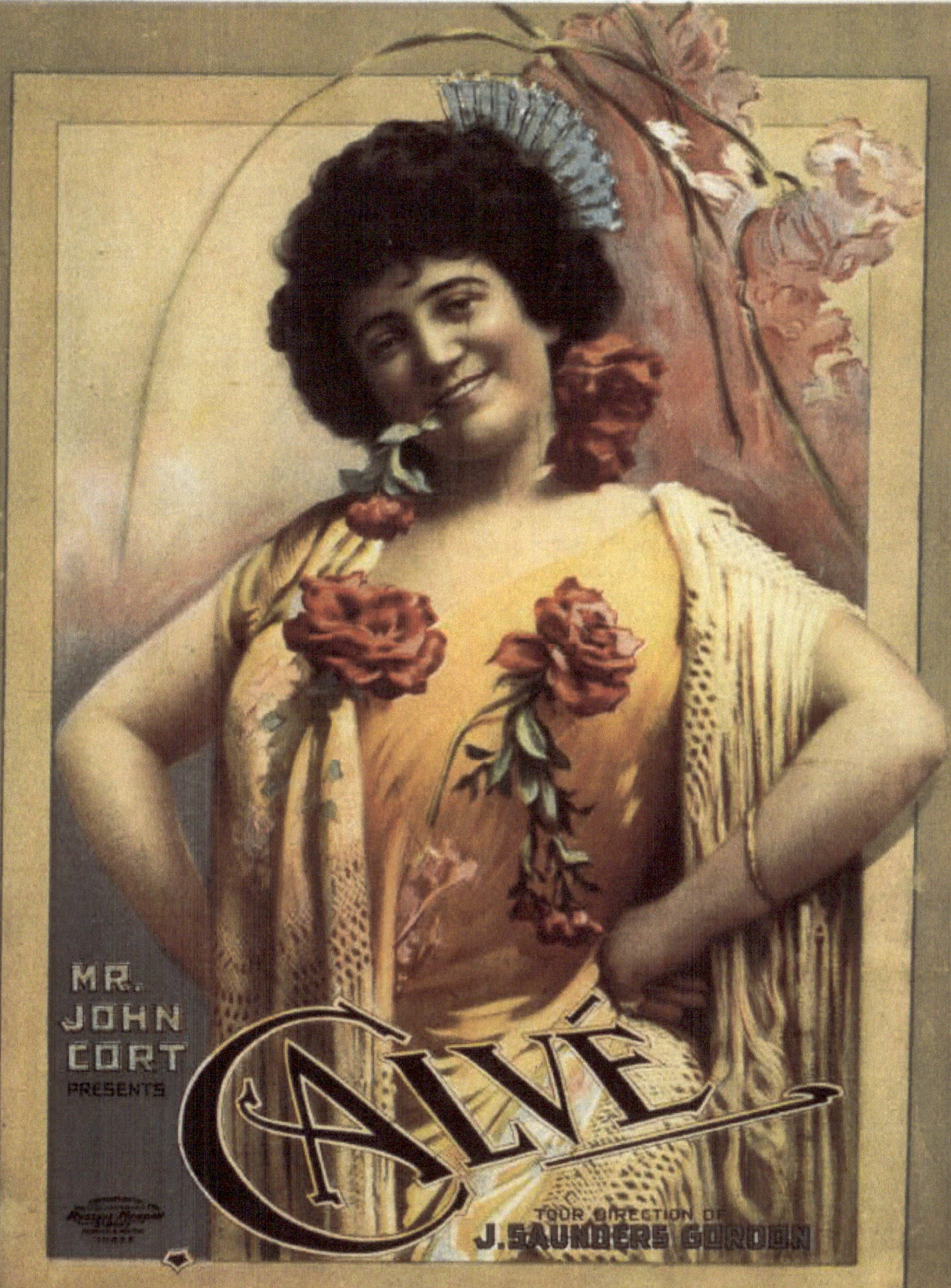

FREDERICK BANCROFT

PRINCE OF MAGICIANS

THE SLAVE OF THE ORIENT

JOSEPH HART VAUDEVILLE Co.

DIRECT FROM
WEBER & FIELDS
MUSIC HALL
NEW YORK CITY.

Fleurette

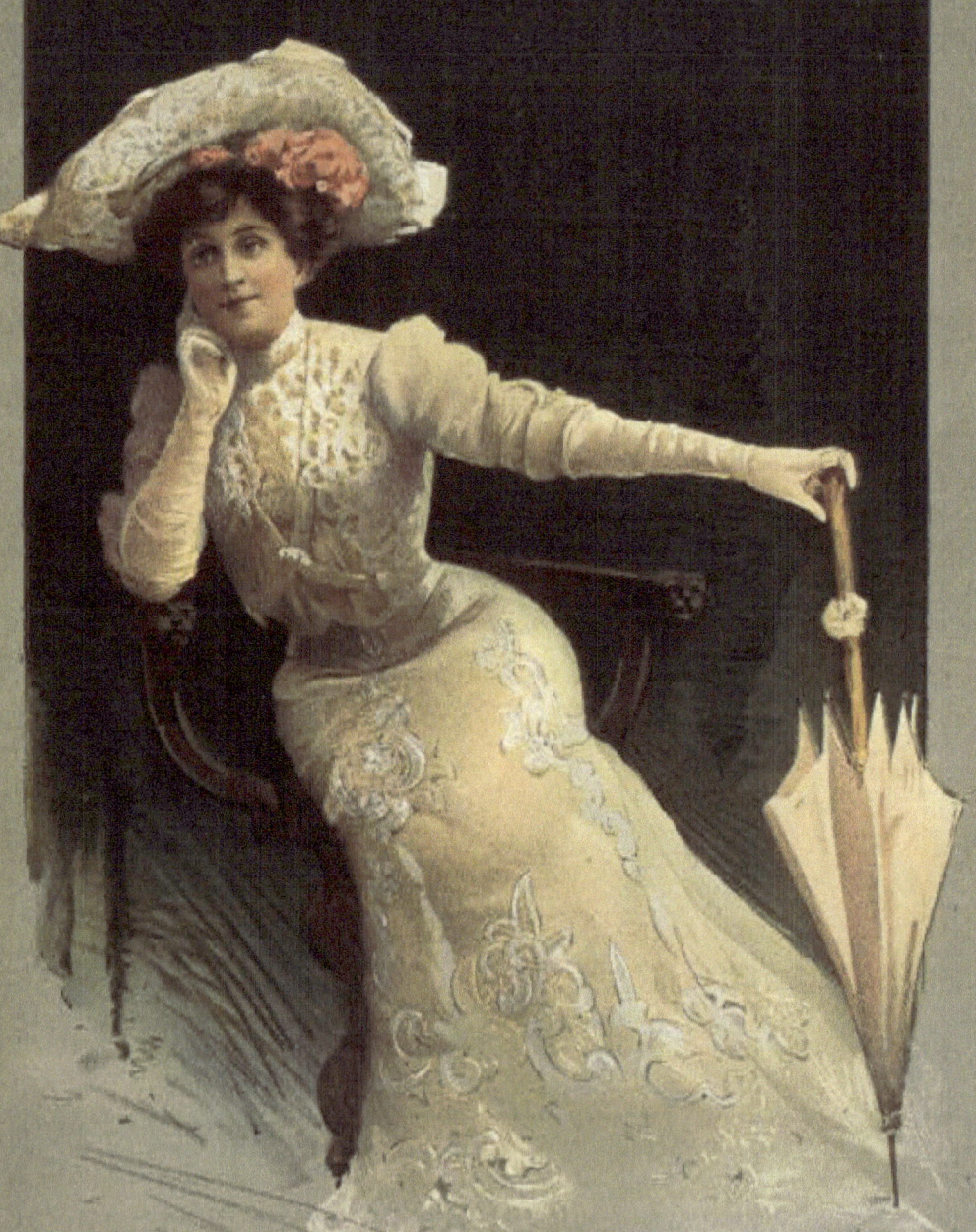

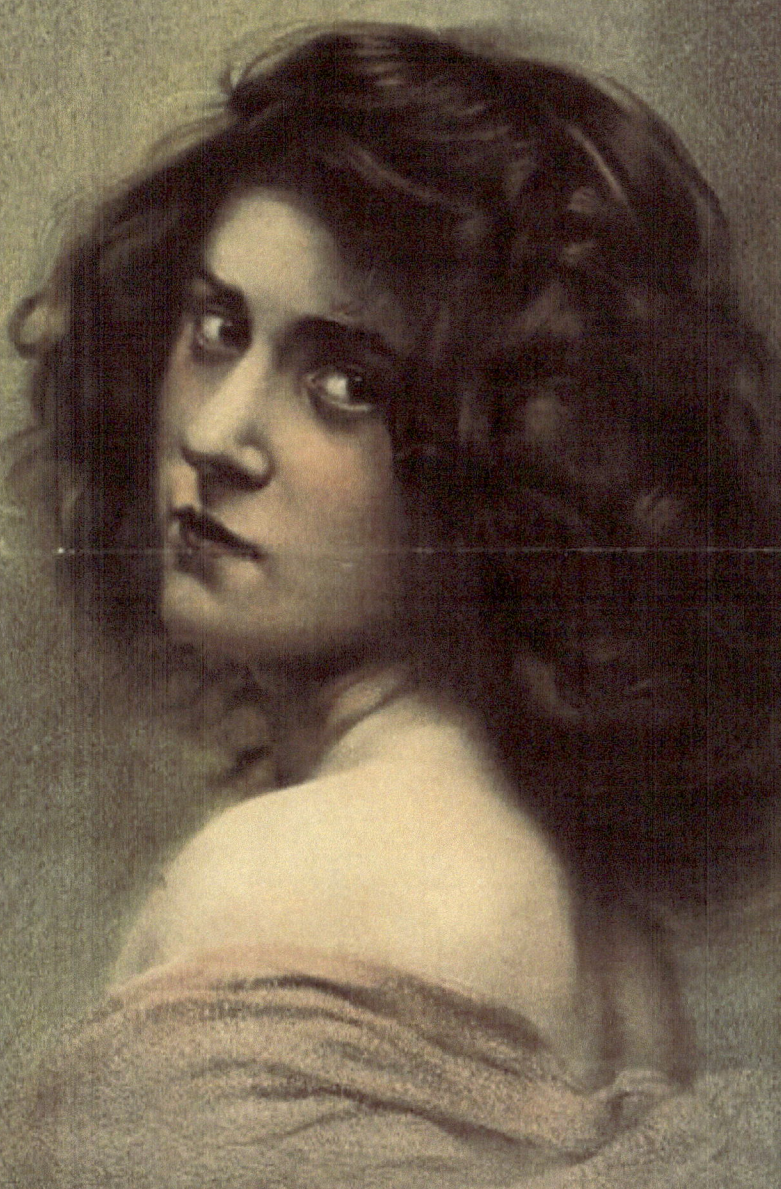

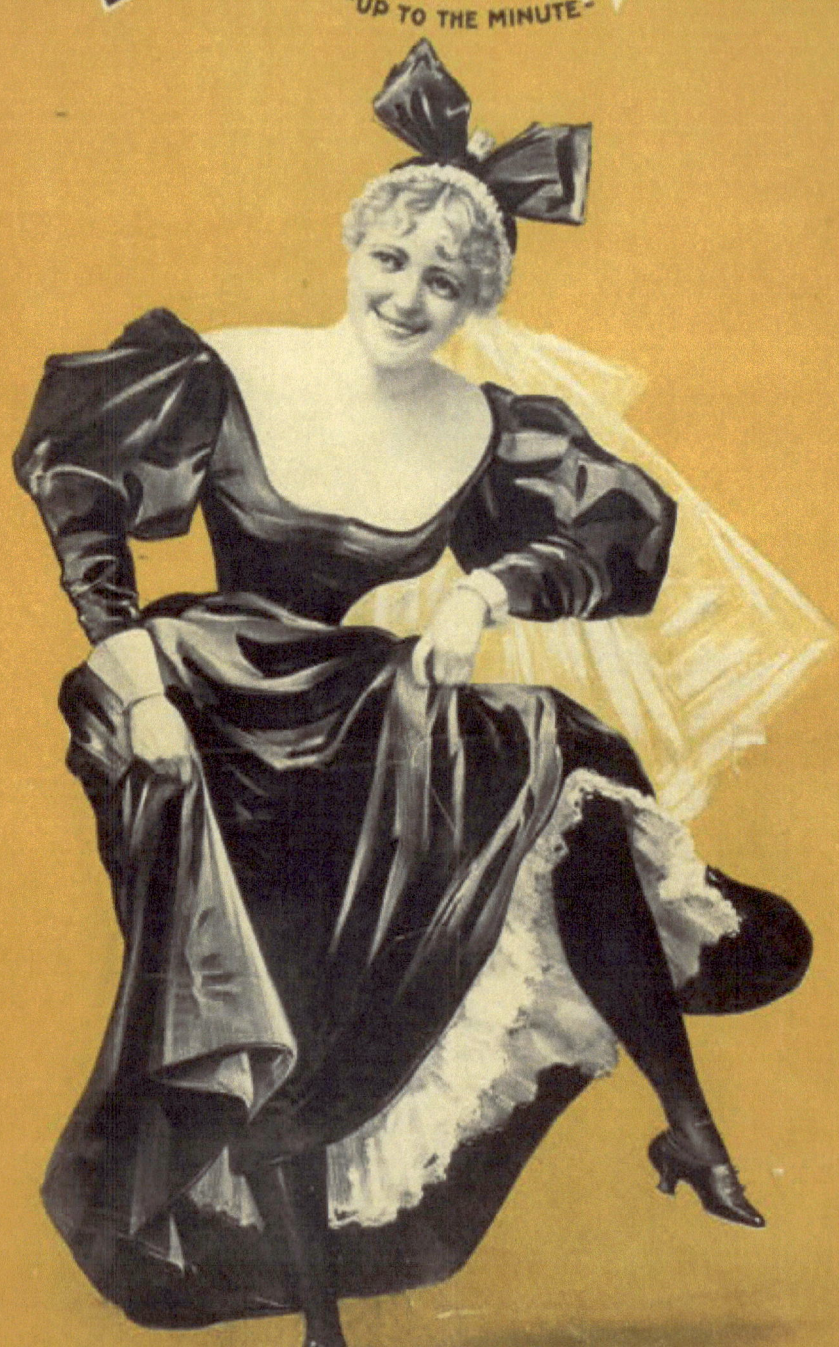

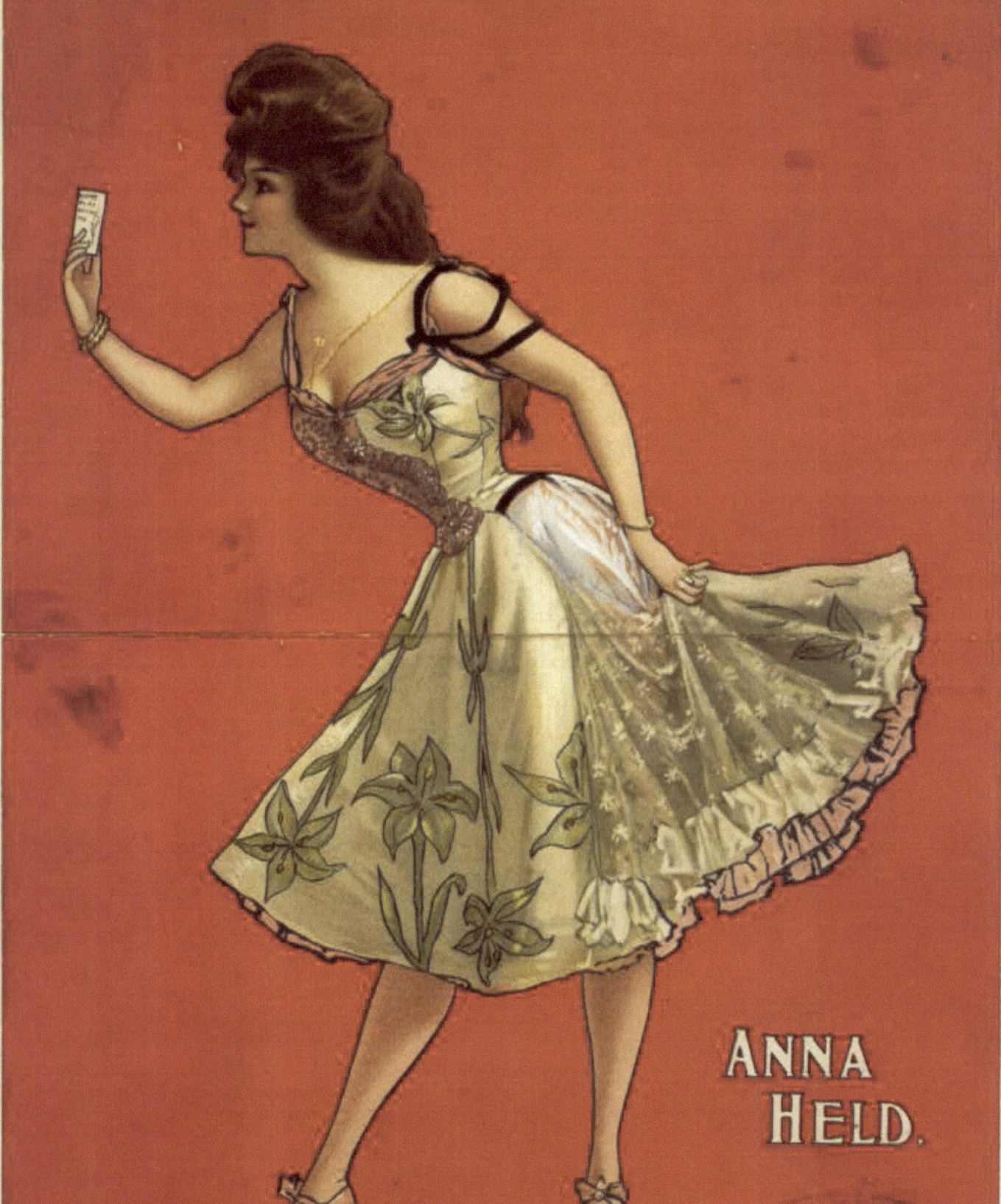

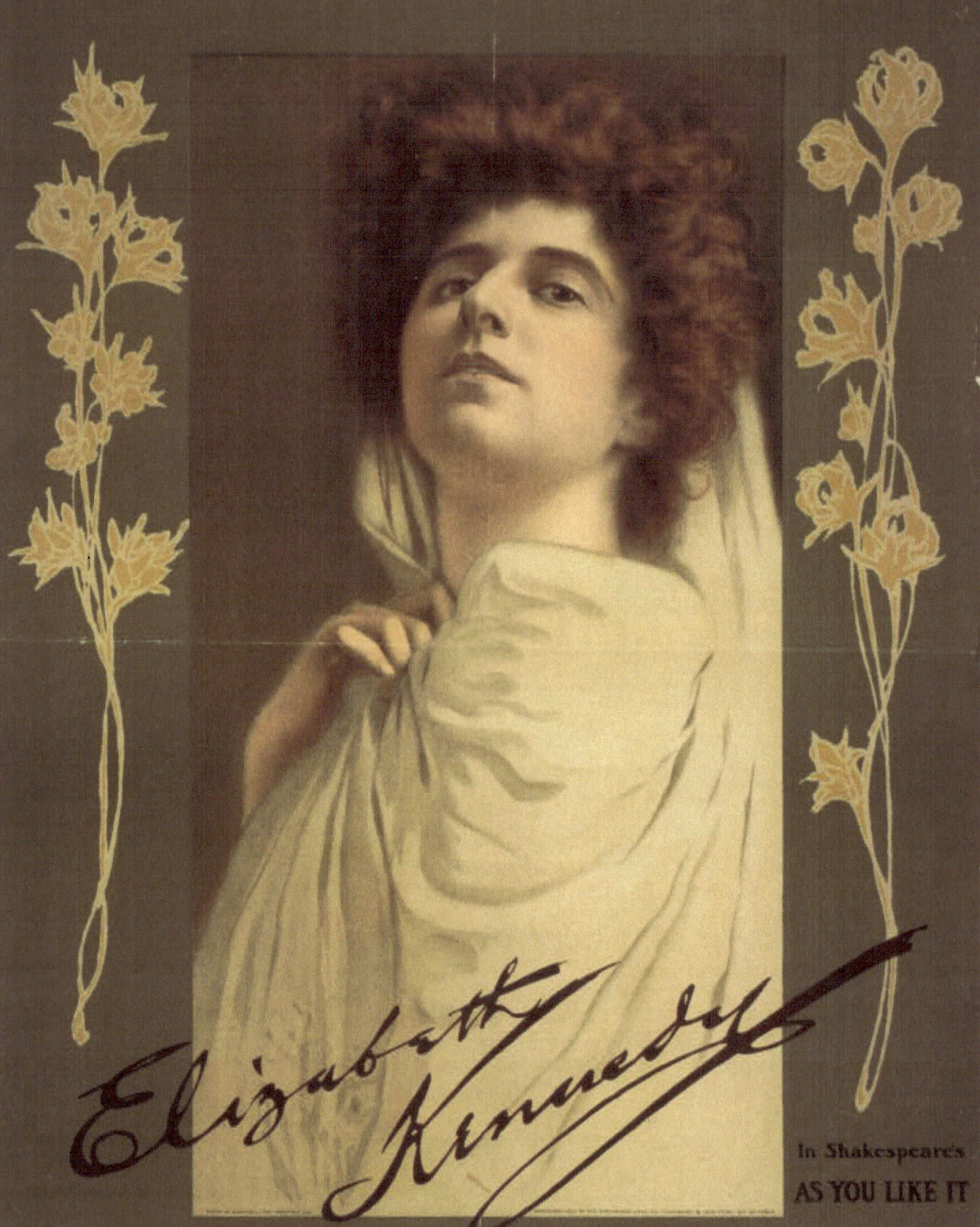

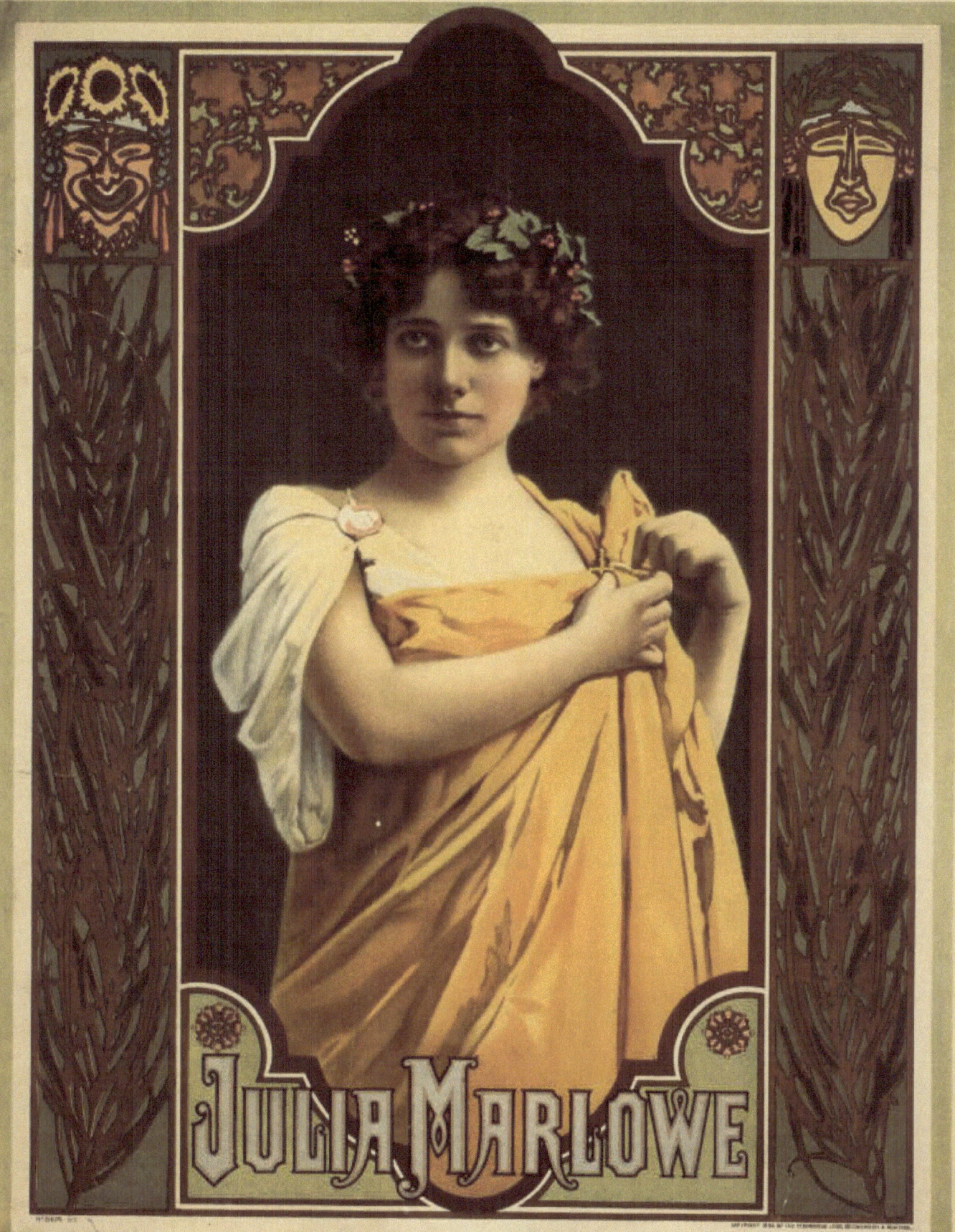

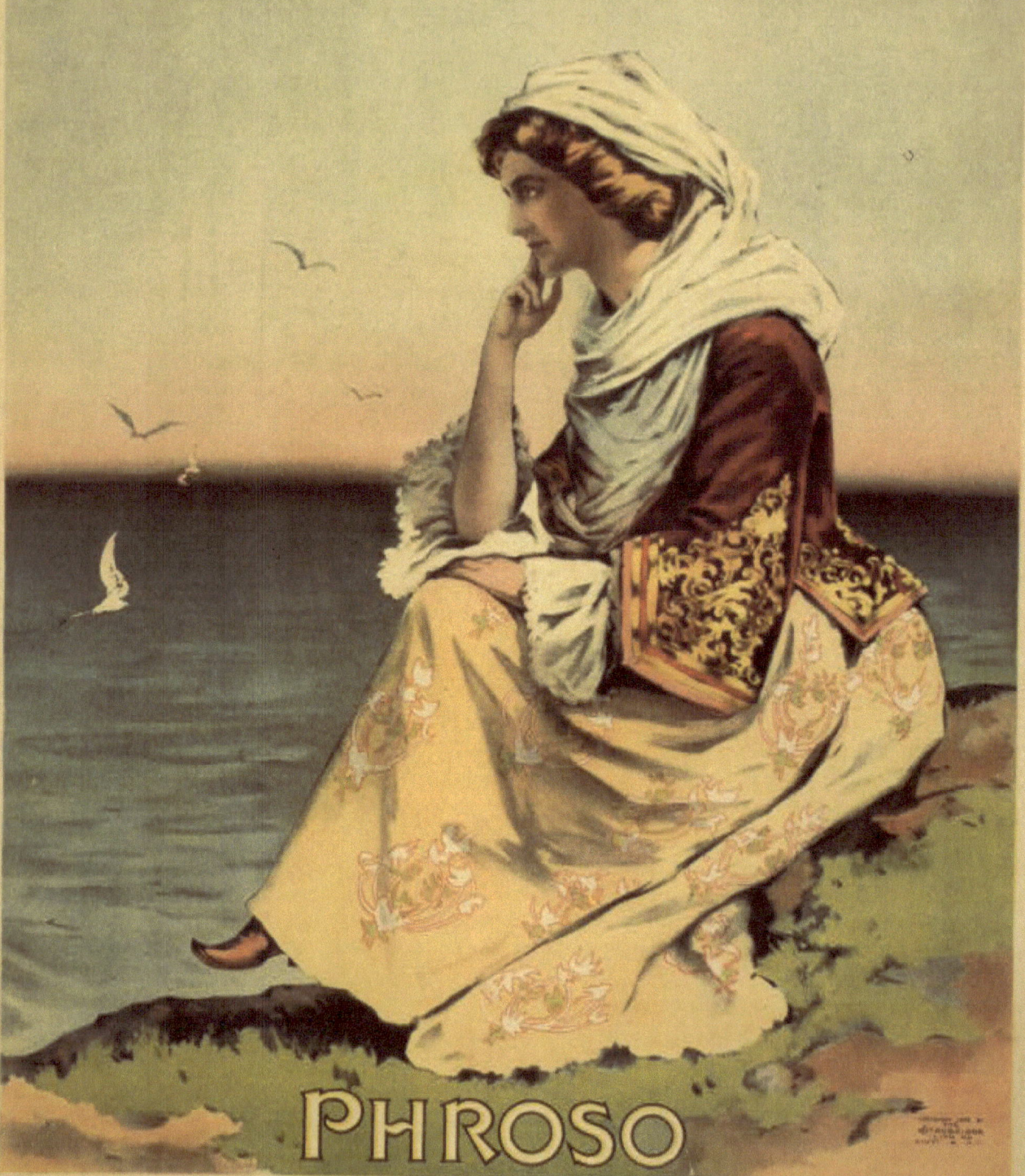

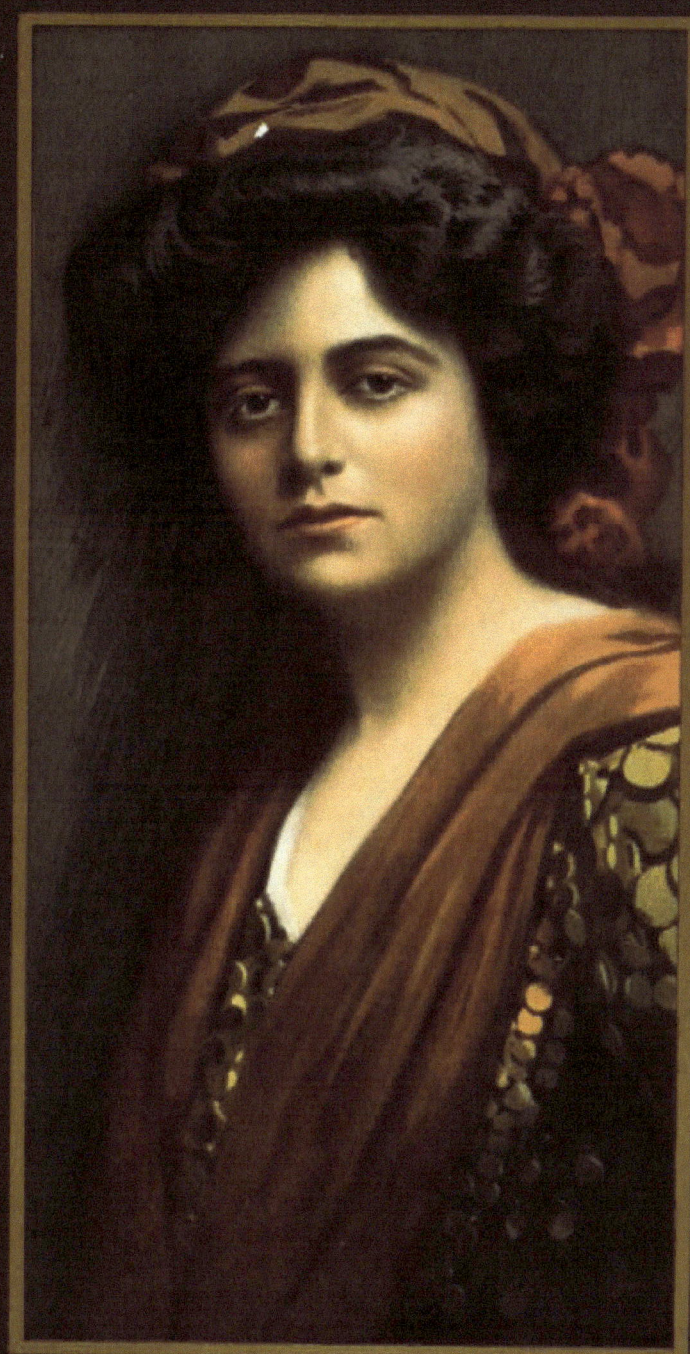

Miss MAXINE ELLIOTT

GEO. J. APPLETON Manager

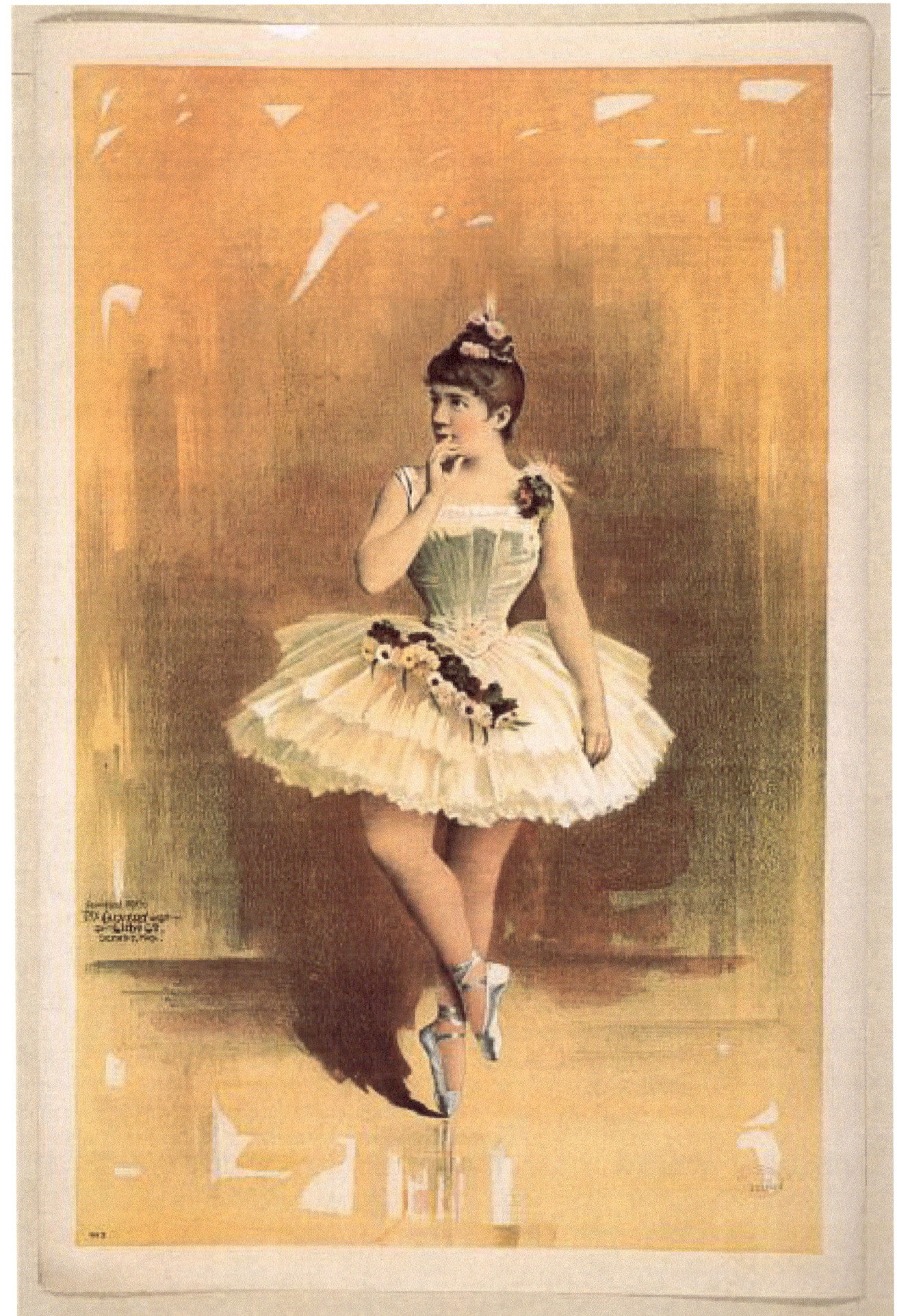

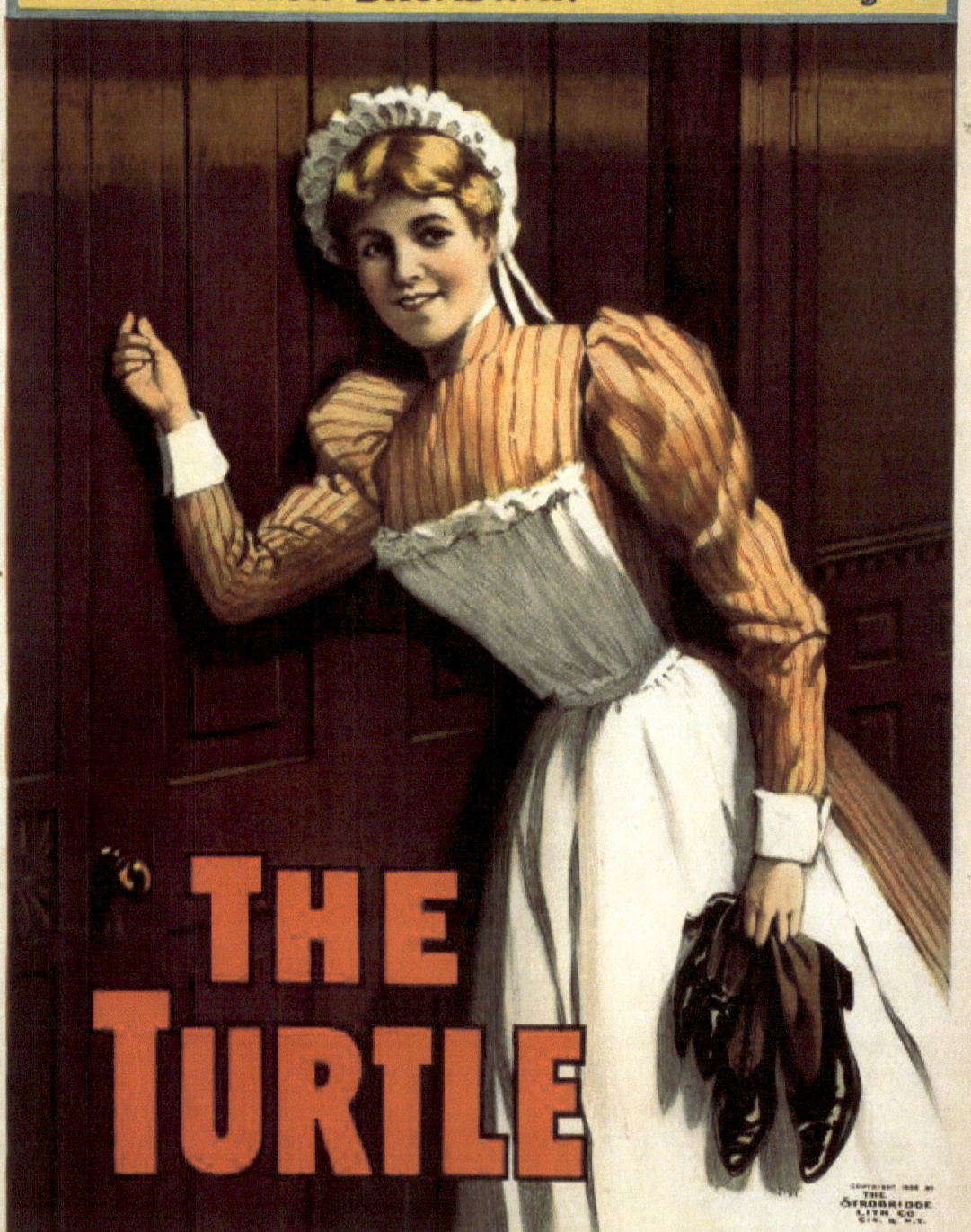

CHAS. E. BLANEY'S BIG EXTRAVAGANZA SUCCESS
A FEMALE DRUMMER
BLANEY AND VANCE, MANAGERS

NELLIE O'NEIL
THE ACROBATIC COMEDIENNE

DICK FERRIS
PRESENTS
THE
GRACE
HAYWARD
CO.

GRACE HAYWARD

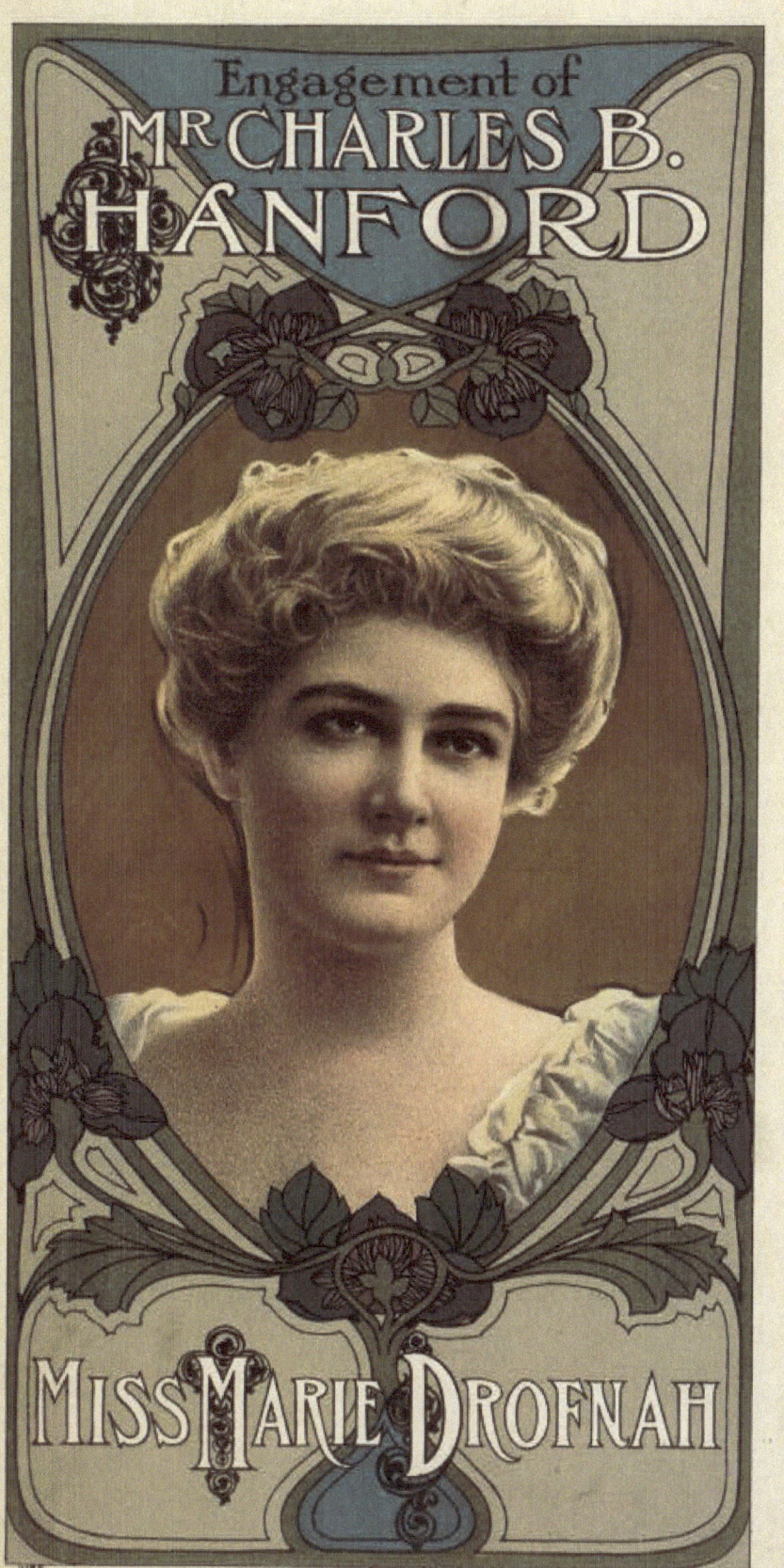

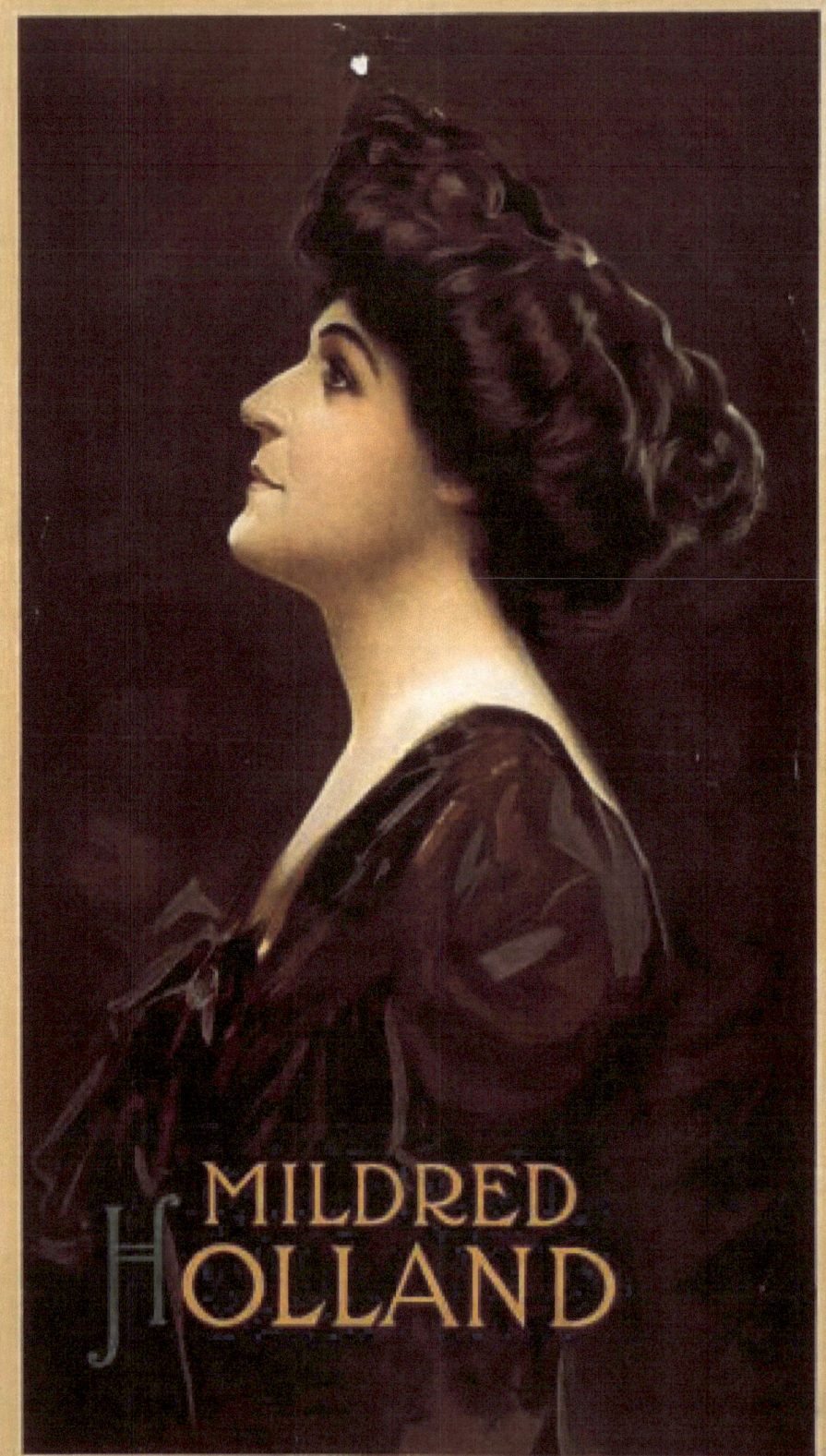

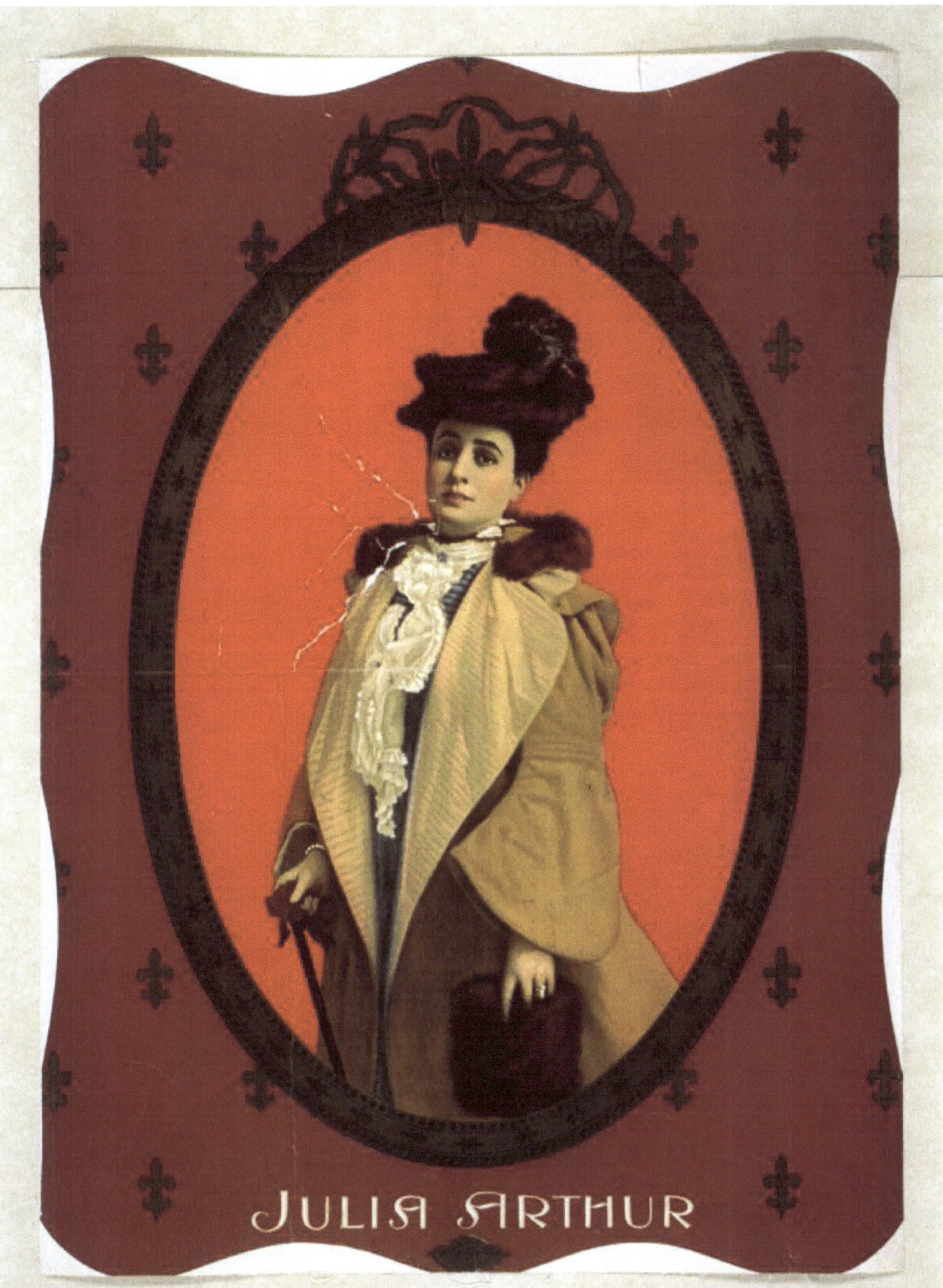

JOSEPH HART VAUDEVILLE CO.

DIRECT FROM
WEBER & FIELDS
MUSIC HALL
NEW YORK CITY.

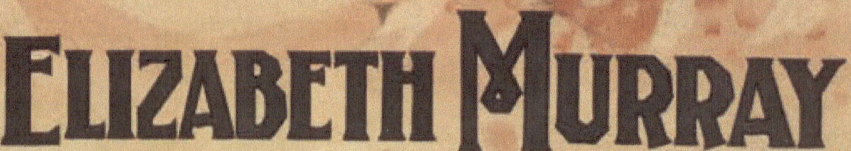

ELIZABETH MURRAY

GEORGE BARR McCUTCHEON'S
Beverly

DIRECTION
A. G. DELAMATER
AND
WILLIAM NORRIS (INC.)

DRAMATIZED FROM
THE NOVEL BY
ROB'T. M. BAKER

BEVERLY CALHOUN

"Devils Auction"
1920.

Plate-W-1401

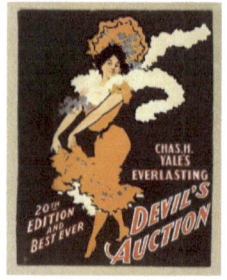

"The Princess Chic"
1900.

Plate-W-1402

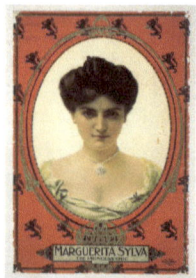

"Miss Maxine Elliott"
1905

Plate-W-1403

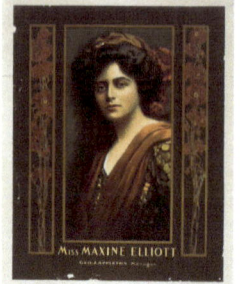

"Elizabeth Kennedy in Shakespeare's As You Like It"
1903.

Plate-W-1404

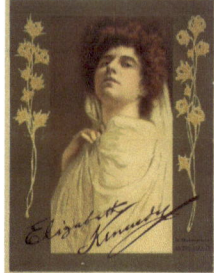

"Sapho New York's Raging Sensation"
1900.

Plate-W-1405

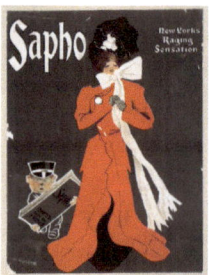

"Sweely, Shipman & Co. Present The Duchess of Devonshire"
1906.
Plate-W-1406

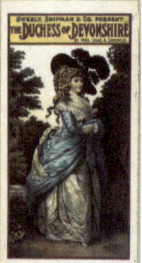

"Maude Fealy"
1906

Plate-W-1407

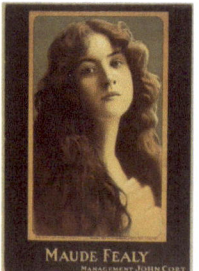

"Girls"
1910

Plate-W-1408

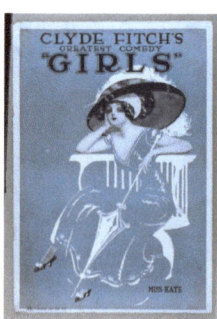

"Girls"
1910

Plate-W-1409

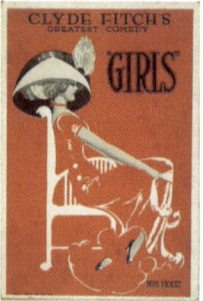

"Girls"
1910

Plate-W-1410

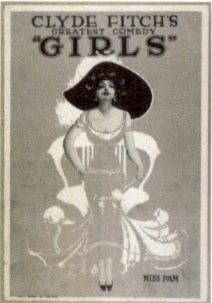

"Nellie McHenry in A Night At the Circus by H. Grattan Donnelly"
1893
Plate-W-1411

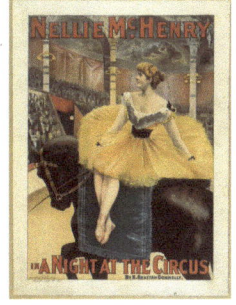

"Eugenie Blair"
1899
Plate-W-1412

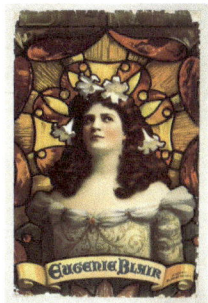

"Rosabel Morrison in Carmen"
1896
Plate-W-1413

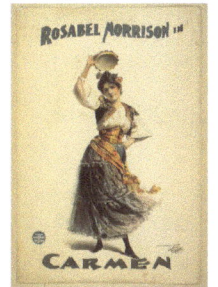

"Silver Spur"
1887
Plate-W-1414

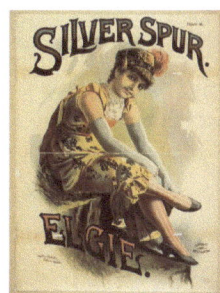

"Ferris' Comedians"
1900
Plate-W-1415

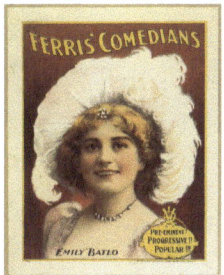

"Mr. John Cort Presents Calve"
1907
Plate-W-1416

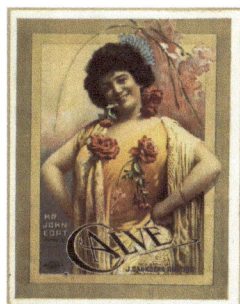

"Frederick Bancroft, Prince of Magicians"
1895
Plate-W-1417

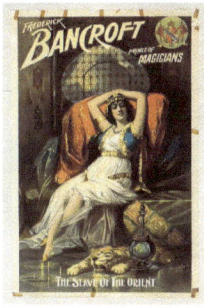

"Joseph Hard Vaudeville Co. Direct from Weber & Fields Music Hall, New York City"
1899
Plate-W-1418

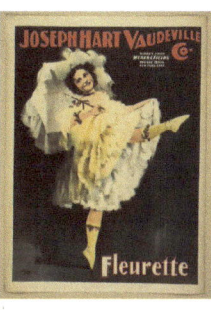

"The Emotional Actress, Alberta Gallatin"
1906
Plate-W-1419

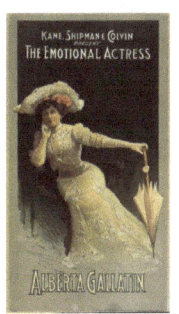

"Hurly-Burly Extravaganza and Refined Vaudeville"
1899
Plate-W-1420

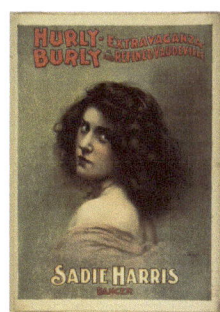

"Weber's Parisian Widows Up to the Minute"
1897

Plate-W-1421

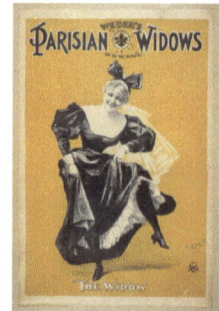

"Anna Held"
1899

Plate-W-1422

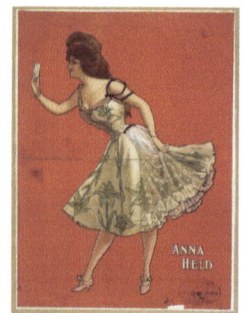

"Henri Gressit Presents Eugenie Blair in David Belasco's Great Play, Zaza"
1903
Plate-W-1423

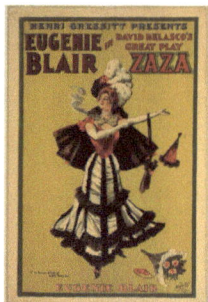

"Julia Marlowe"
1899

Plate-W-1424

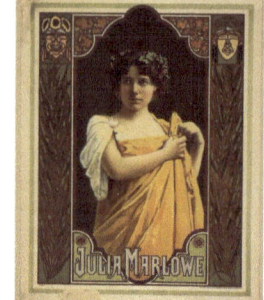

"Phroso by Anthony Hope"
1898

Plate-W-1425

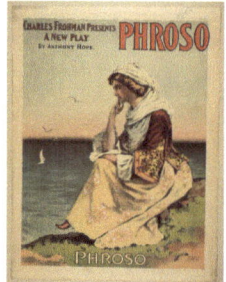

"Selden's Funny Farce, A Spring Chicken"
1898

Plate-W-1426

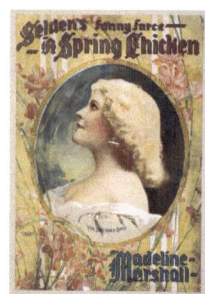

"Ballerina in White Costume with Flowers in Dance Pose"
1890

Plate-W-1427

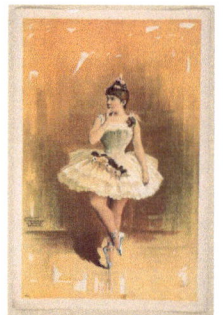

"Hoyt's A Brass Monkey"
1900.

Plate-W-1428

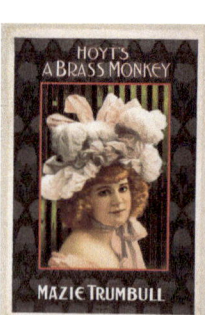

"The Turtle F. Ziegfeld Jr's Production"
1898

Plate-W-1429

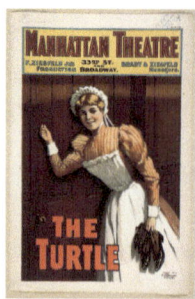

"Chas. E. Blaney's Big Extravaganze Success, A Female Drummer"
1899

Plate-W-1430

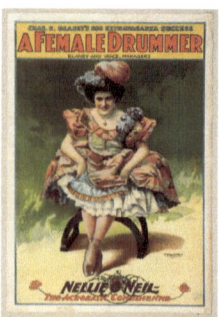

"Dick Ferris Presents the Grace Hayward Co."
1900

Plate-W-1431

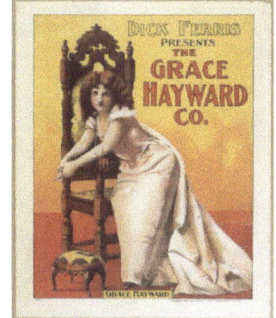

"Engagement of Mr. Charles B. Hanford"
1906

Plate-W-1432

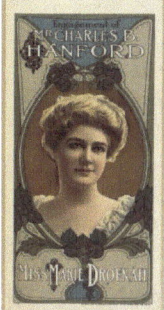

"Mildred Holland"
1908

Plate-W-1433

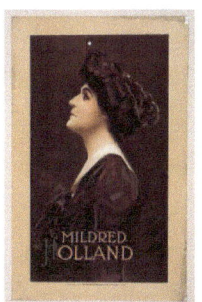

"Julia Arthur"
1899

Plate-W-1434

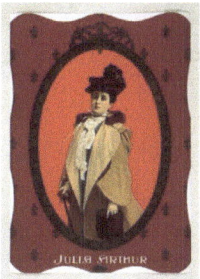

"Elizabeth Murray"
1899

Plate-W-1435

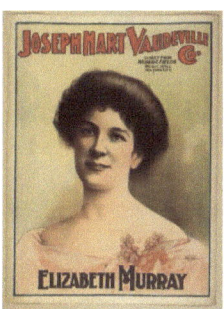

"Beverly"
1904

Plate-W-1436

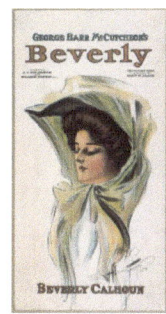

To Order Posters and Inquire about Sizes and Prices:

Email Poster Number (Plate-W-14XX) to
manager@worldgreatart.com

World Great Art™ Publishing

www.WorldGreatArt.com

2013

www.ingramcontent.com/pod-product-compliance
Lightning Source LLC
Chambersburg PA
CBHW050835180526
45159CB00004B/1916